St Marys Ontario Book 4 in Colour Photos, Saving Our History One Photo at a Time

Photography
by Barbara Raué
2015

Series Name:
Cruising Ontario

Book 132: St. Marys Book 4

Cover photo: Widder Street, Page 27

Series Name: Cruising Ontario
Saving Our History One Photo at a Time
in colour photos

Books Available in Alphabetical Order:
Aberfoyle, Acton, Alton, Ancaster, Arthur, Aylmer, Ayr, Bloomingdale, Brantford, Burlington, Caledon, Caledonia, Cambridge, Clifford, Conestogo, Delhi, Dorchester to Aylmer, Drayton, Drumbo, Dundas, Eden Mills, Elmira, Elora, Fergus, Guelph, Hagersville, Hamilton, Hanover, Harriston, Hespeler, Jarvis, Kitchener, Linwood, Listowel, London, Lucknow, Mono, Mount Forest, Neustadt, New Hamburg, Niagara-on-the-Lake, Oakville, Orangeville, Orillia, Owen Sound, Palmerston, Peterborough, Port Elgin, Preston, Rockwood, Seaforth, Sheffield, Shelburne, Simcoe, Southampton, St. Jacobs, St. Thomas, Stoney Creek, Stratford, Tillsonburg, Waterdown, Waterford, Waterloo, Wellesley, Wingham

Book 110:Lucknow,Mitchell
Book 111: Conestogo, Bloomingdale
Book 112: Delhi
Book 113: Waterford
Book 114-116: Waterloo
Book 117-119: Windsor
Book 120-121: Amherstburg
Book 122: Essex
Book 123-124: Kingsville
Book 125-127: Woodstock
Book 128: Thamesford
Book 129-132: St. Mary's

Other Books by Barbara Raue

Coins of Gold

Arrows, Indians and Love

The Life and Times of Barbara
Volume 1: Inventions That Have Enhanced My Life
Volume 2: Entertainment That I Have Enjoyed
Volume 3: East Coast Trips
Volume 4: Olympics Have Always Intrigued Me
Volume 5: Wonders of the World
Volume 6: Caribbean Cruises We Have Enjoyed
Volume 7: Animals
Volume 8: Storms and Other Major Disasters in My Lifetime
Volume 9: Wars, Terrorist Attacks and Major Disasters

The Cromwell Family Book

Laura Secord Discovered

Daddy Where Are You?

Visit Barbara's website to view all of her books
http://barbararaue.ca

Table of Contents

Wellington Street North Page 6

Wellington Street South Page 13

Widder Street East Page 27

William Street Page 36

Architectural Terms Page 37

Building Styles Page

St. Marys, known as Stonetown, is set in a beautiful valley beside the majestic Thames River. It is a town in southwestern Ontario located southwest of Stratford. St. Marys' early economic success depended on the mills powered by the water in this river.

From stunning architecture to picturesque views, St. Marys has a special character all of its own.

John Grieve Lind (1867-1947) was closely associated with the start of the St. Mary's Cement Company. St. Marys was chosen as the location for the plant because of its abundance of limestone, clay and water, it was on two national railway lines, and it had access to hydro-electric power from Niagara Falls. The plant opened in 1912.

Once the cement plant was in operation, Lind turned his attention to parks and recreation. He purchased the seven acre Cadzow Park on Church Street South and built Cadzow Pool. Lind Park now contains a statue of Arthur Meighen, Canada's ninth prime minister.

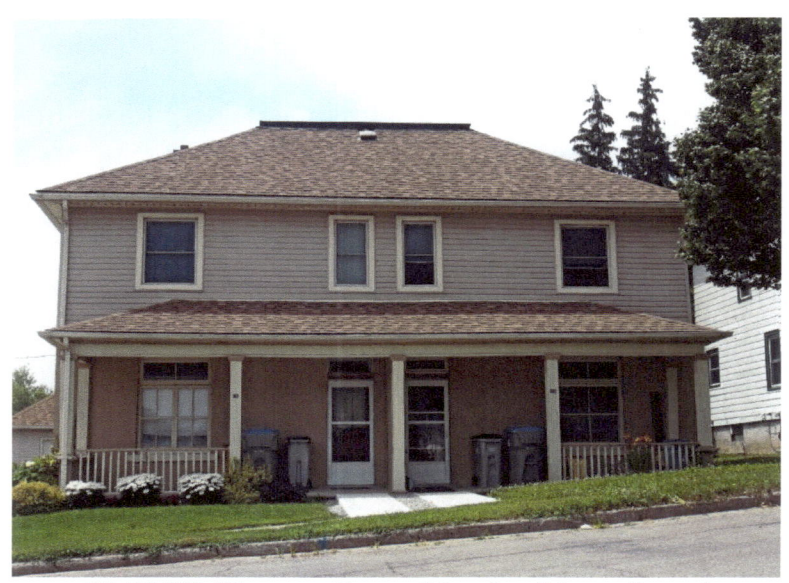

70-72 Wellington Street North – hipped roof

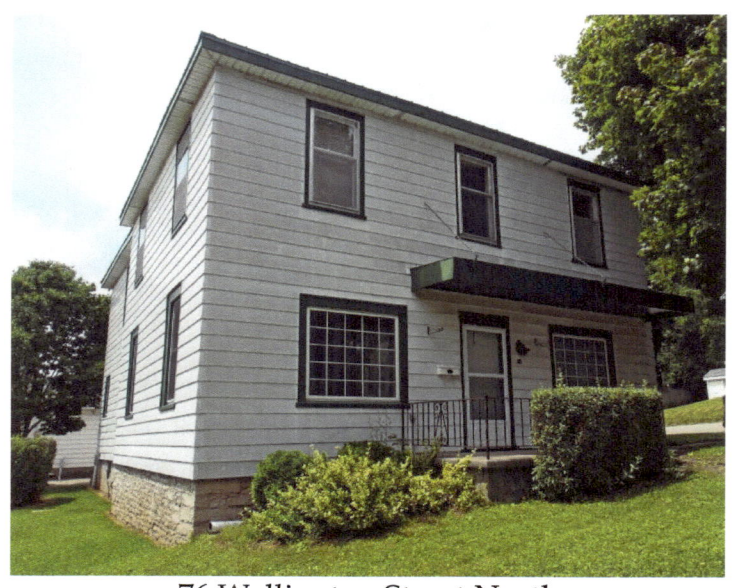

76 Wellington Street North

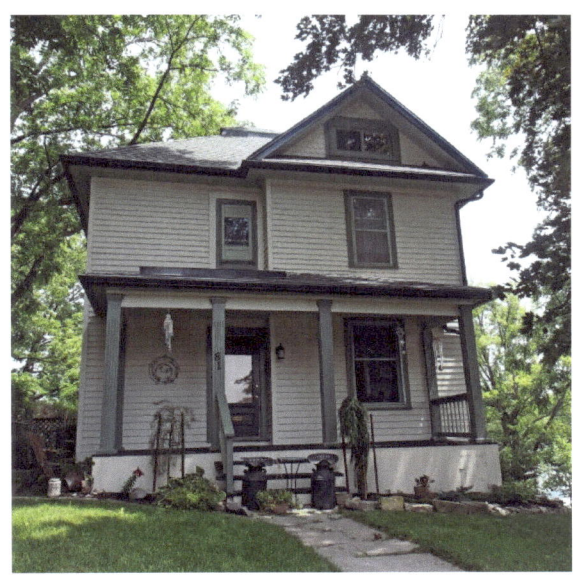

81 Wellington Street North - Edwardian

89 Wellington Street North – Palladian window on left

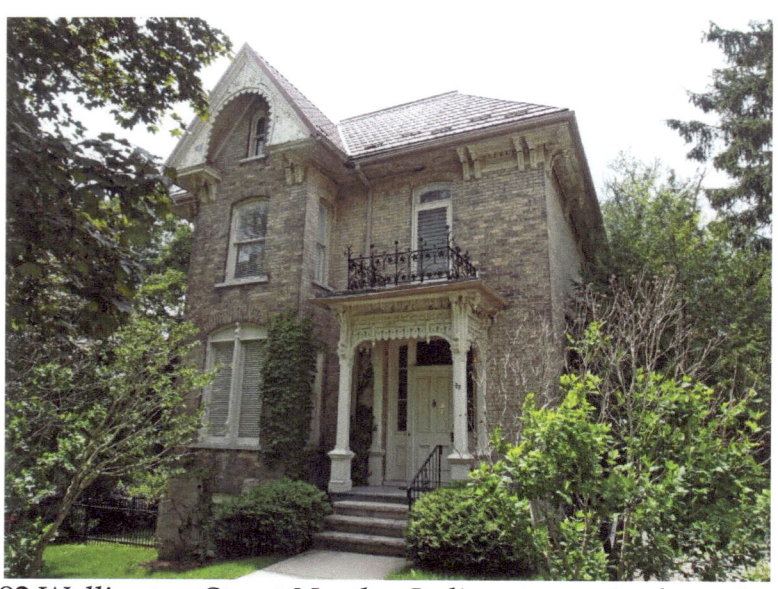
92 Wellington Street North – Italianate – paired cornice brackets, 2½ storey tower-like bay with verge board trim on gable, iron cresting above entrance porch

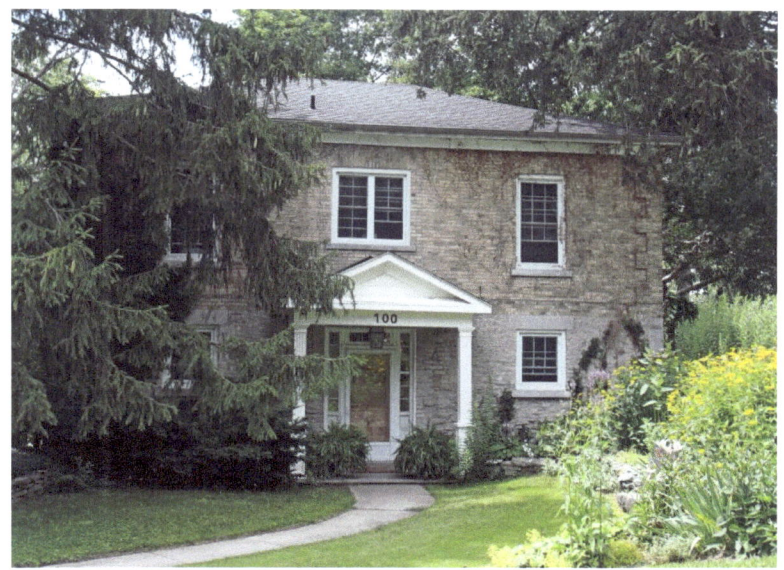

100 Wellington Street North – hipped roof, full two storeys, pediment above porch, sidelights and transom windows around door

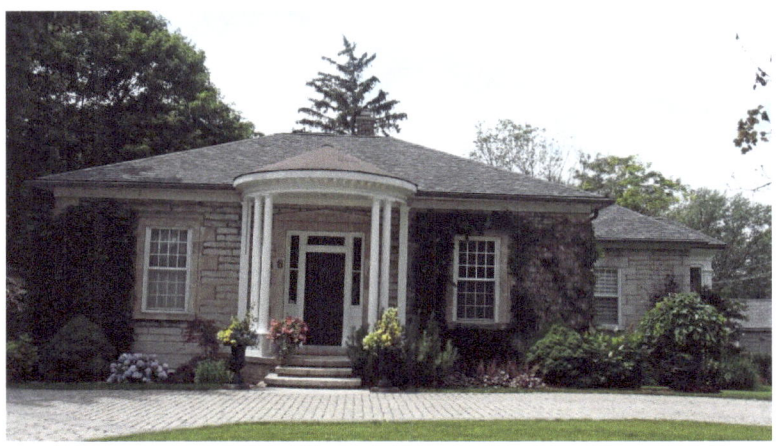

106 Wellington Street North – Regency Cottage, hipped roof

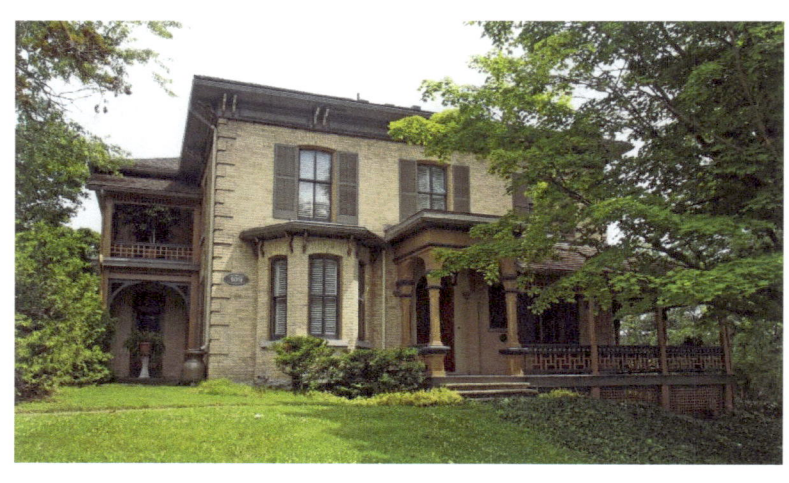

109 Wellington Street North – 1874,
Mary Harrison Mathieson first owner
Italianate, paired cornice brackets, bay window, corner quoins

154 Wellington Street North – hipped roof, bay window, sidelights and transom

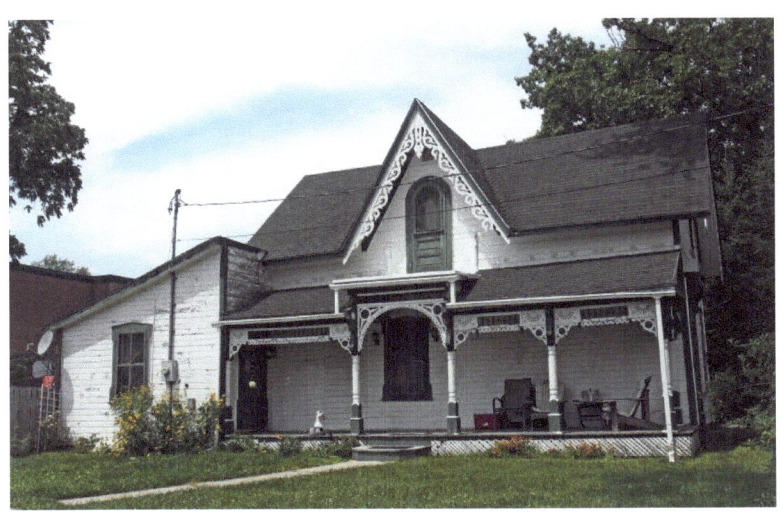

146 Wellington Street North – Gothic Revival, verge board trim on gable, bric-a-brac and stenciling on porch

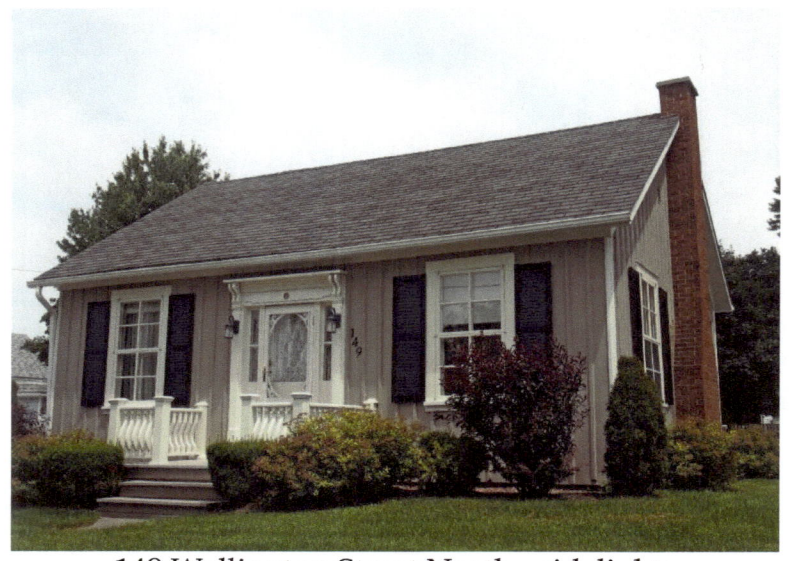

149 Wellington Street North - sidelights

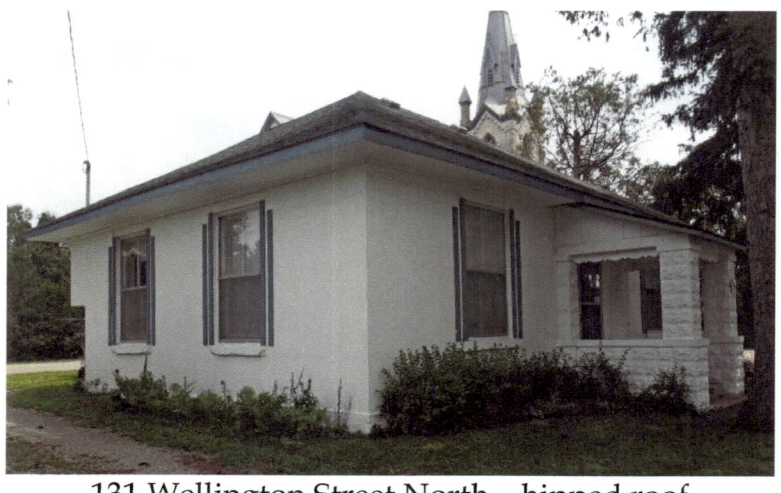

131 Wellington Street North – hipped roof

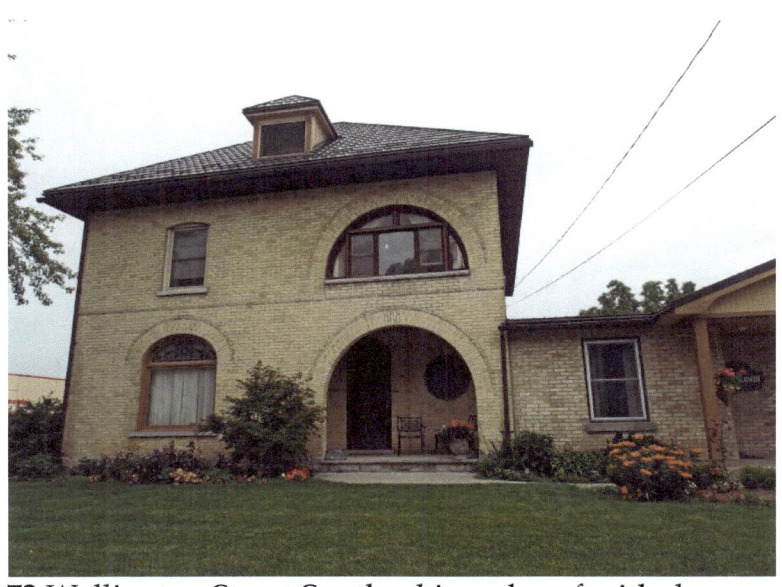

72 Wellington Street South – hipped roof with dormer, Romanesque style window and door arches

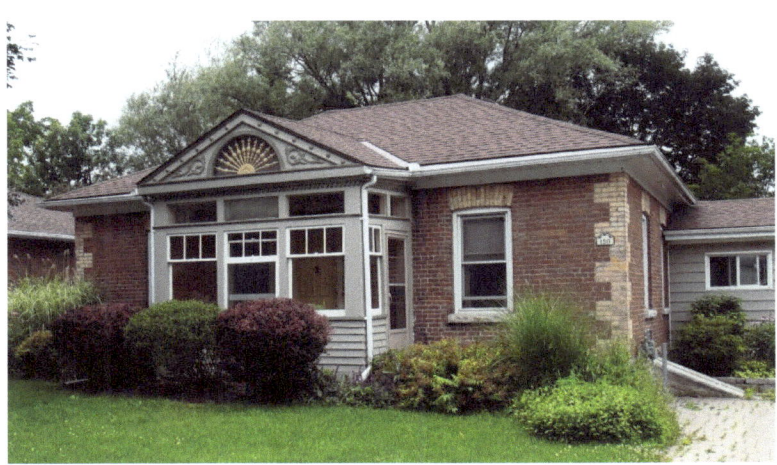

130 Wellington Street South – pediment with decorated tympanum with spindles in sunburst, corner quoins

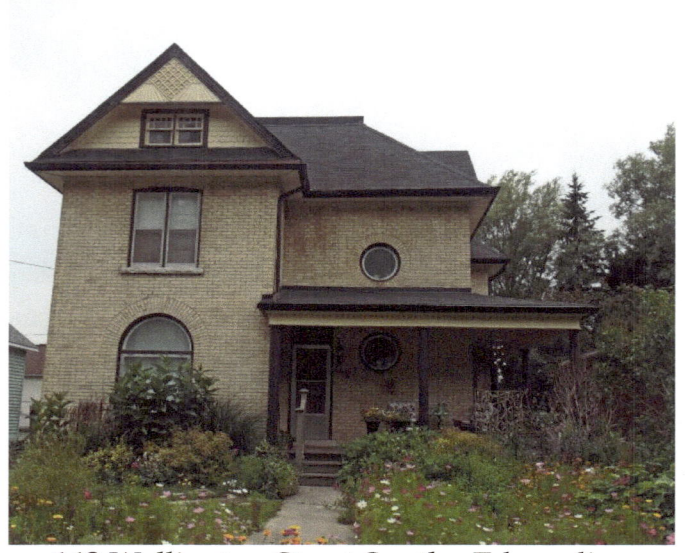

142 Wellington Street South - Edwardian

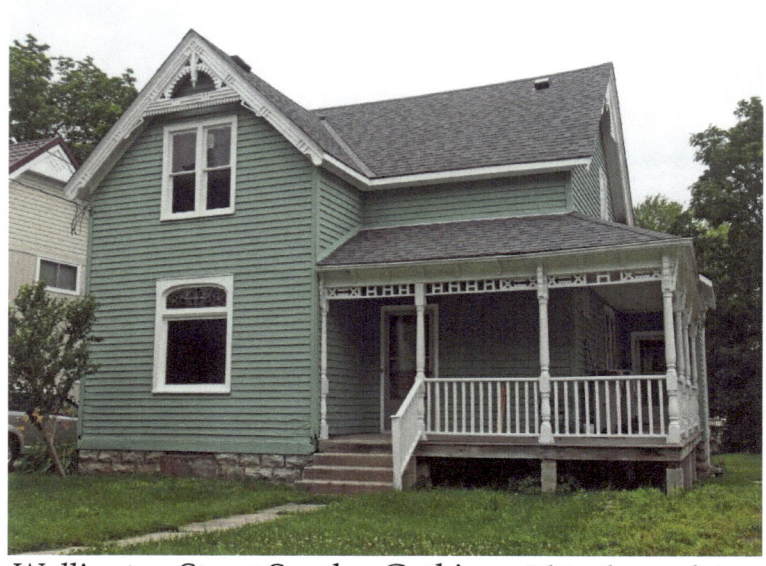

Wellington Street South – Gothic - within the peak is a decorative arch with spindles

152 Wellington Street South

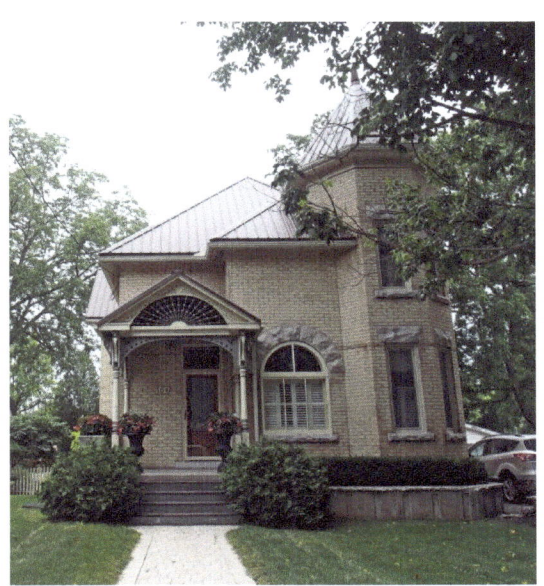

164 Wellington Street South - pediment

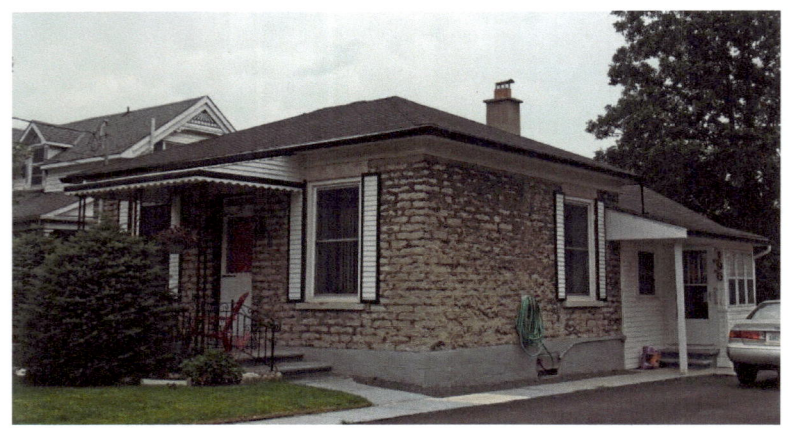

196 Wellington Street South – Regency Cottage

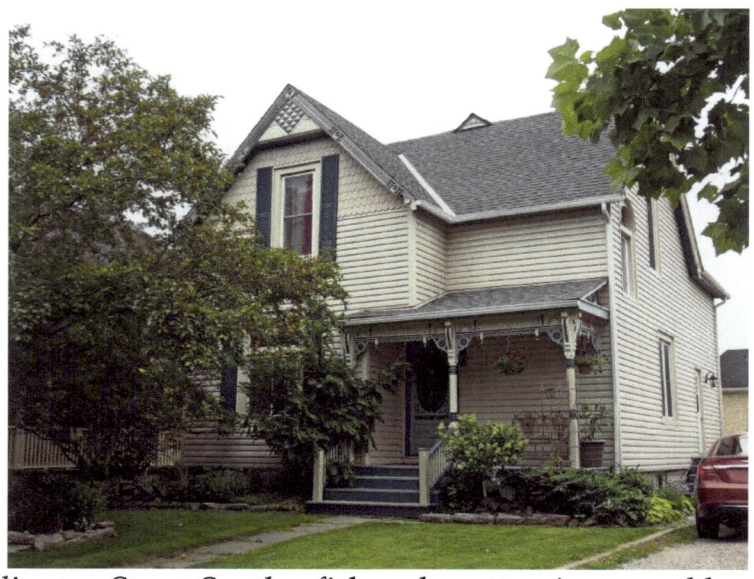

Wellington Street South – fish scale patterning on gable, with decoration at the peak, bric-a-brac on verandah

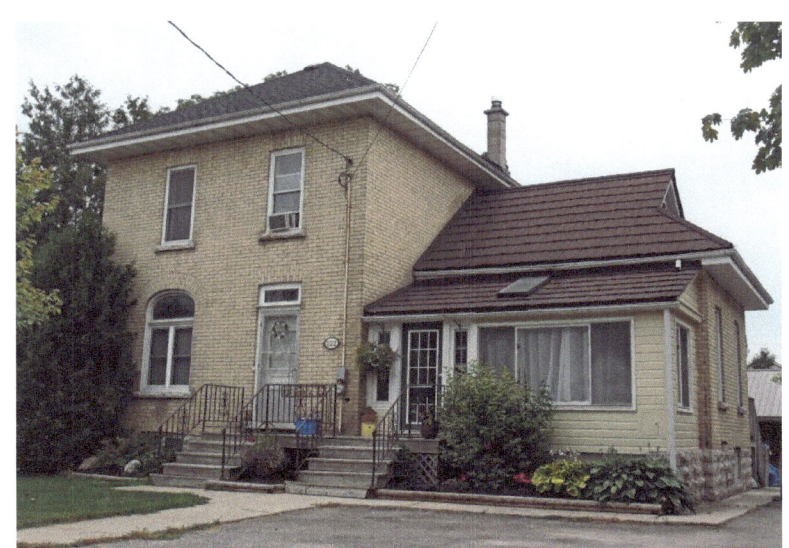

222 Wellington Street South – Italianate, hipped roof, arched window voussoir with stained glass window

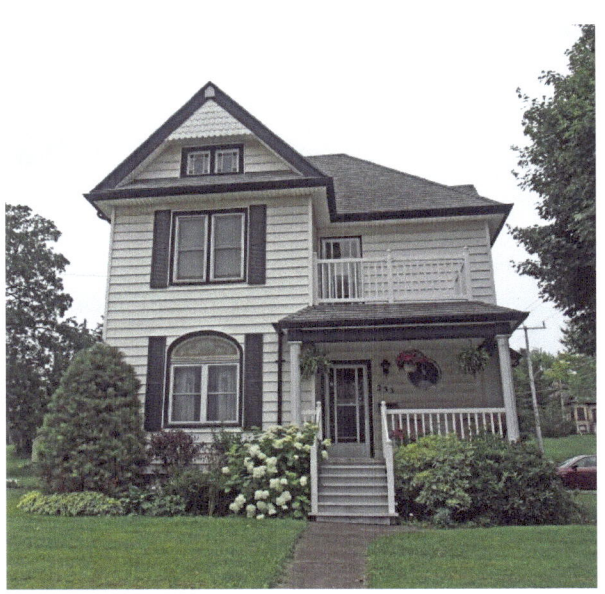

233 Wellington Street South - vernacular

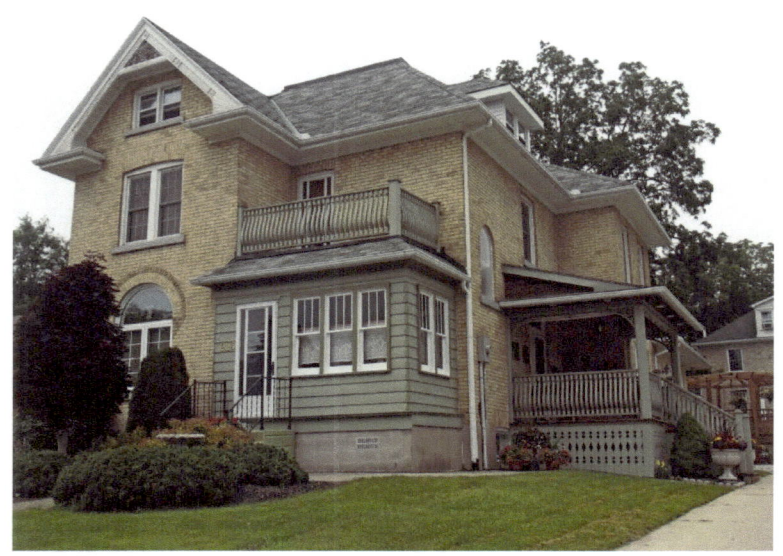

223 Wellington Street South – vernacular – cornice return on gable, dormer in attic, second floor balcony

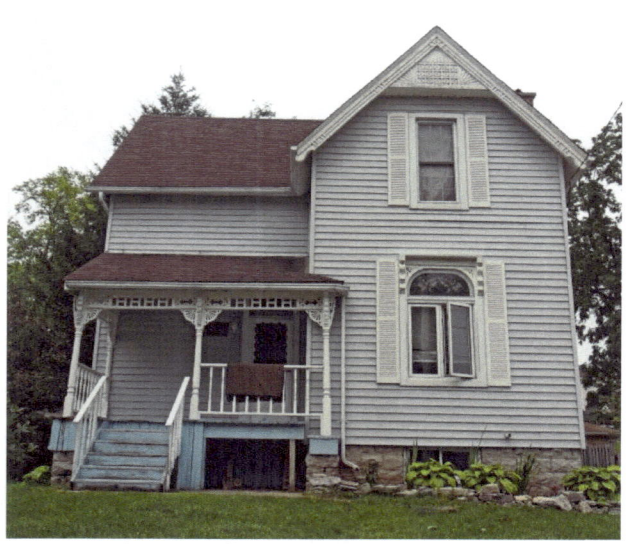

211 Wellington Street South

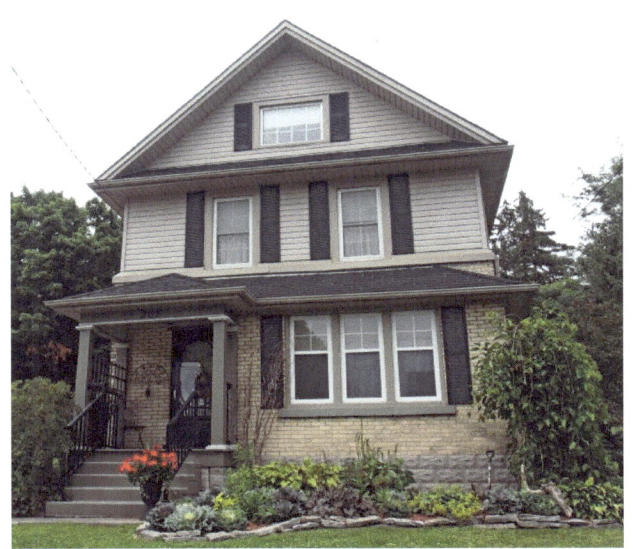

207 Wellington Street South

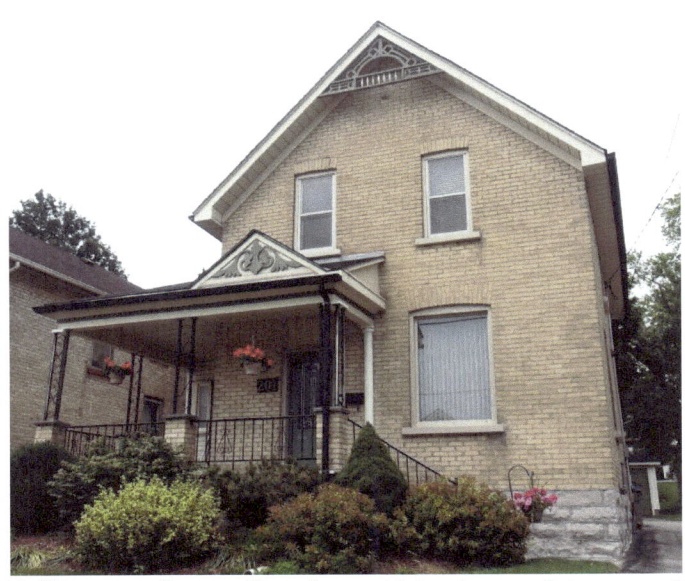

201 Wellington Street South - within the peak is an arch with spindles, pediment above porch

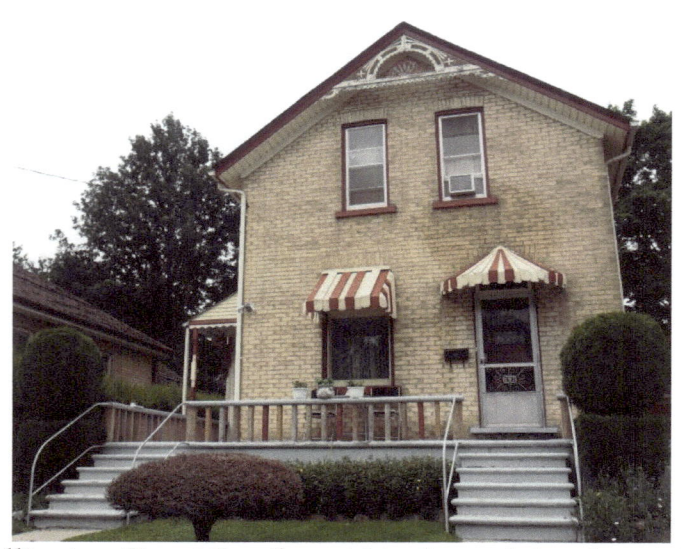

197 Wellington Street South - within the peak is a decorative arch

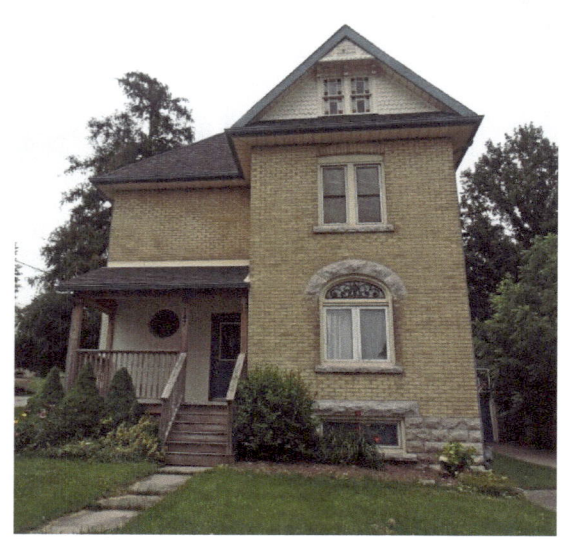

187 Wellington Street South - Edwardian

165 Wellington Street South

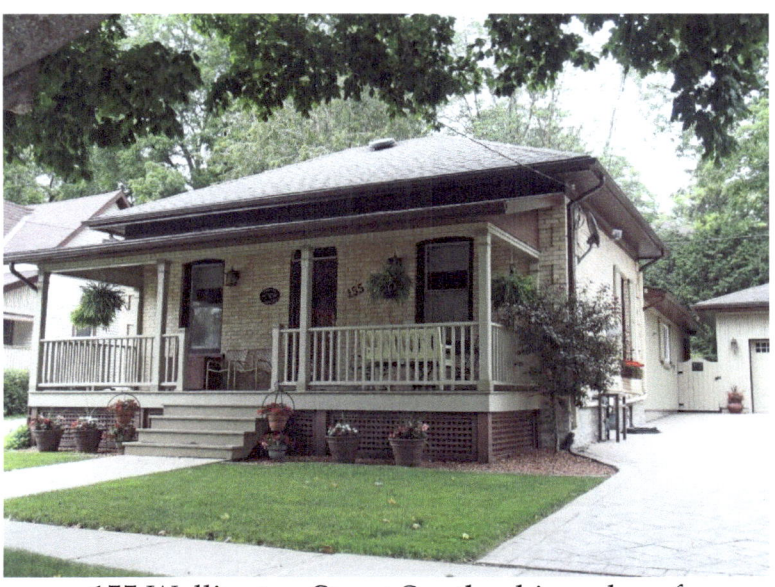

155 Wellington Street South – hipped roof

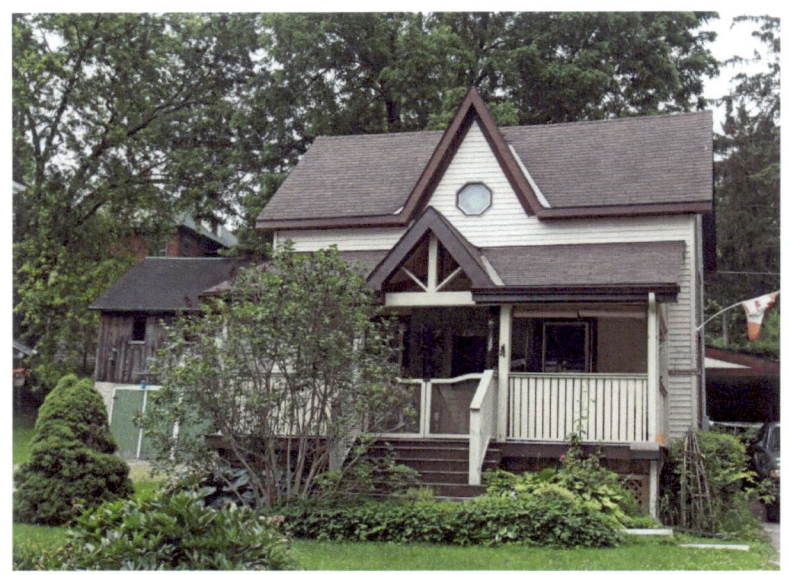

151 Wellington Street South – Gothic Revival

137 Wellington Street South – turned porch supports

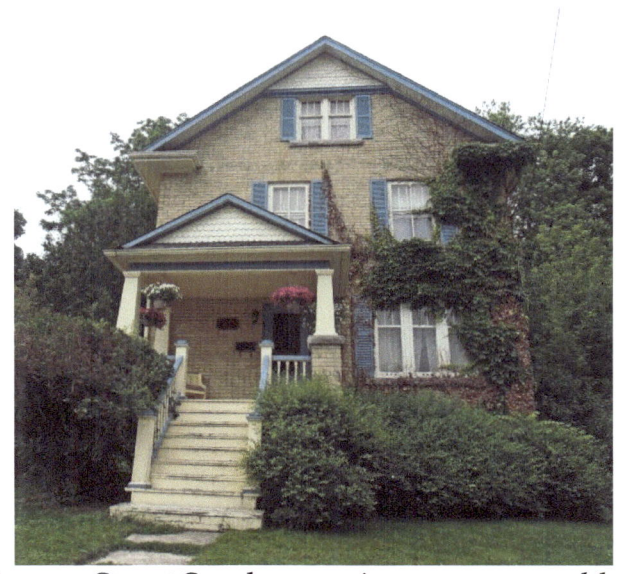

133 Wellington Street South – cornice return on gable with fish scale patterning at top, pediment with fish scale pattern

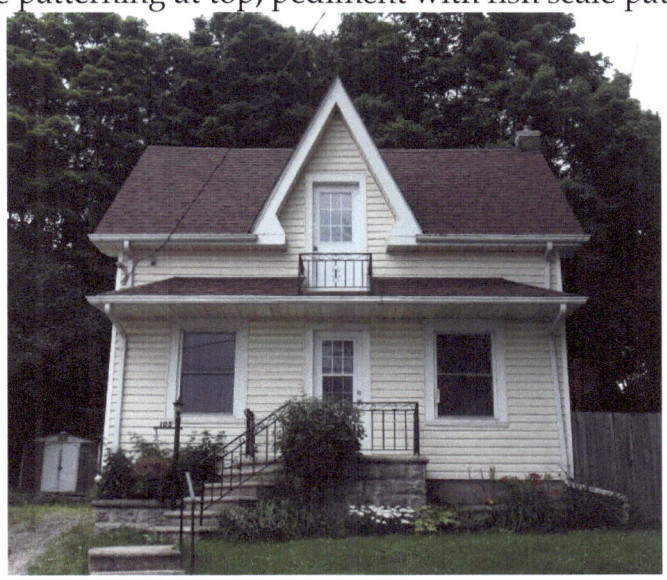

105 Wellington Street South – Gothic Revival 1½ storey cottage with second floor balcony

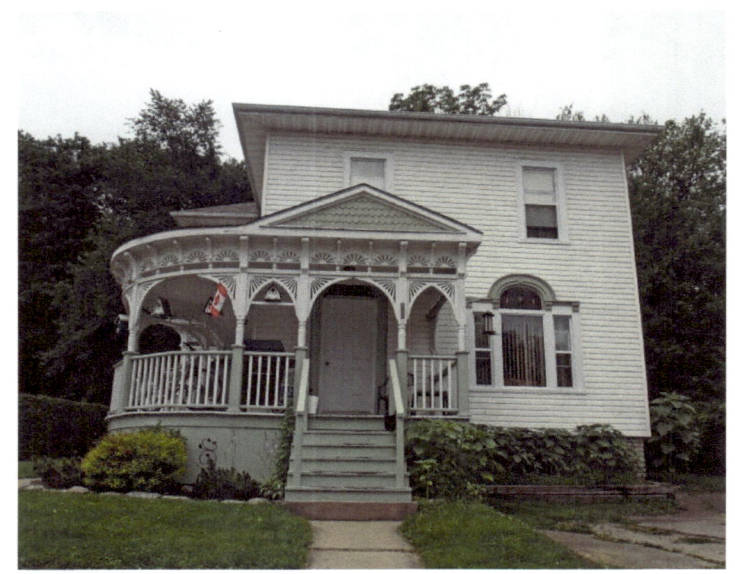

127 Wellington Street South – spindled and stenciled bric-a-brac on wraparound verandah; Palladian type window with window hood and stained glass window

95 Wellington Street South

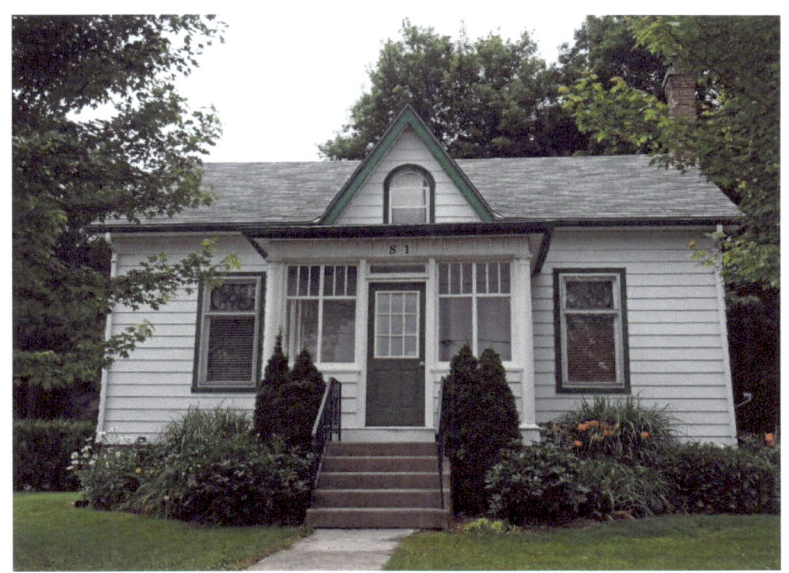

81 Wellington Street South – Regency Cottage

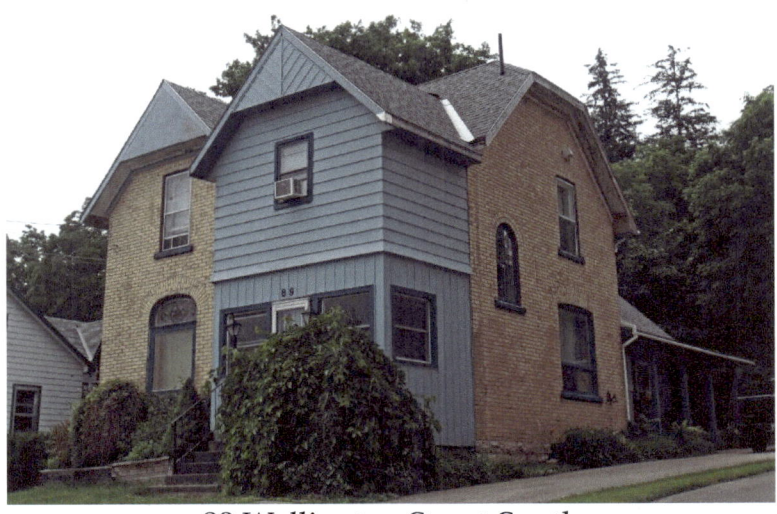

89 Wellington Street South

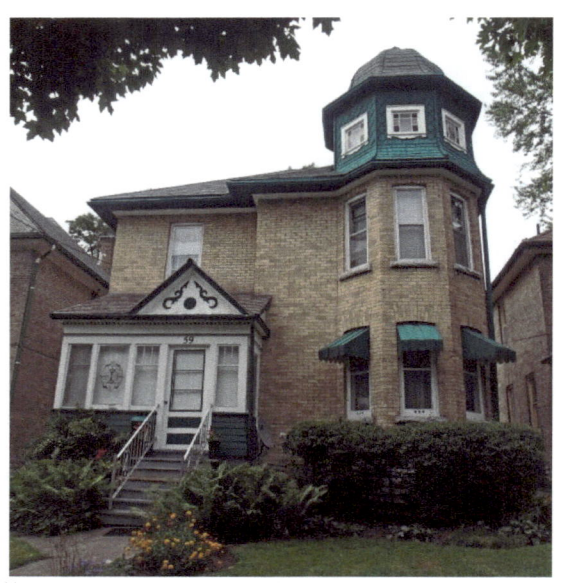

59 Wellington Street South – Queen Anne style with three-storey capped turret

Wellington Street South - Edwardian

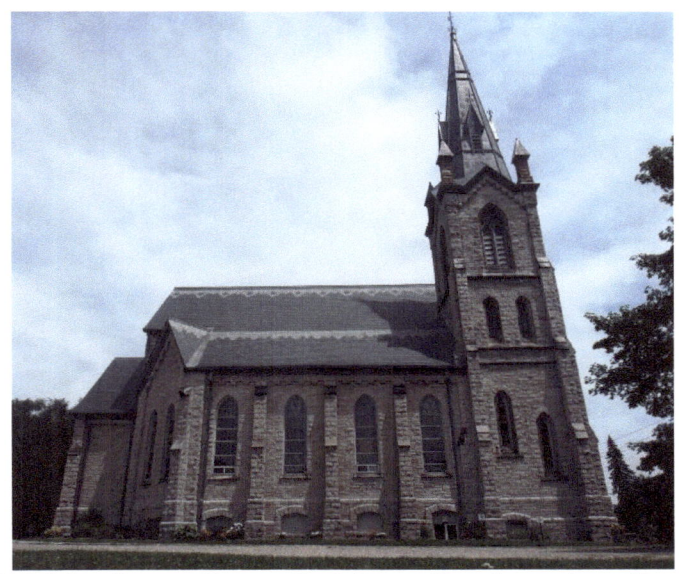

147 Widder Street East – St. Marys Presbyterian Church – Gothic Revival, stone buttresses, lancet windows, turrets, 139-foot tower and steeple – opened in 1881

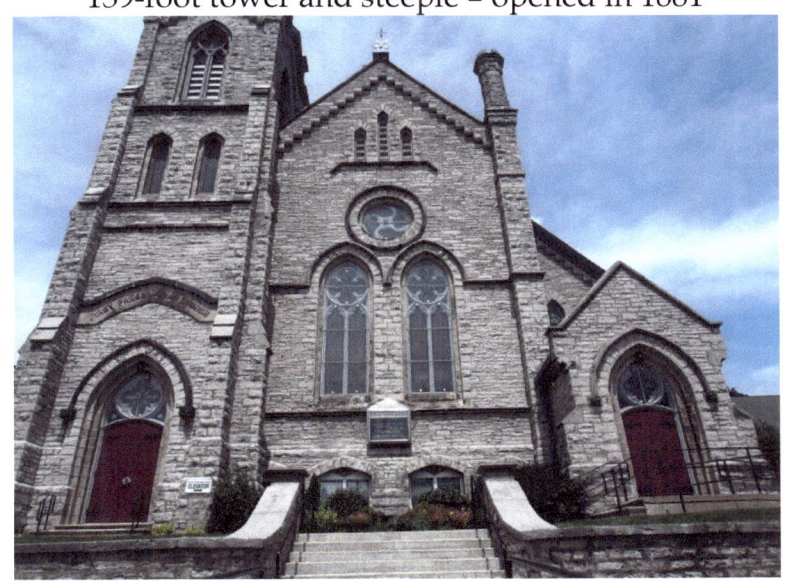

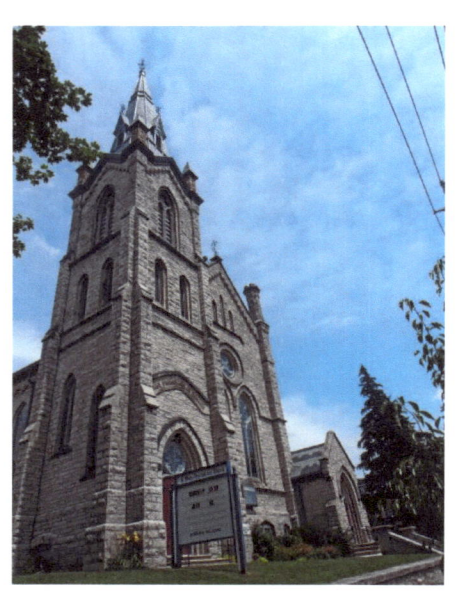

147 Widder Street East

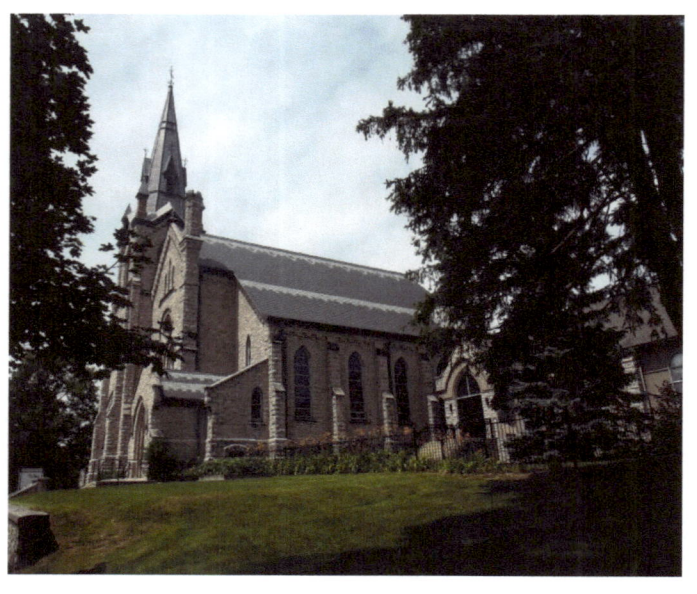

Widder Street East – limestone, dormers, dentil moulding, sandstone lintels

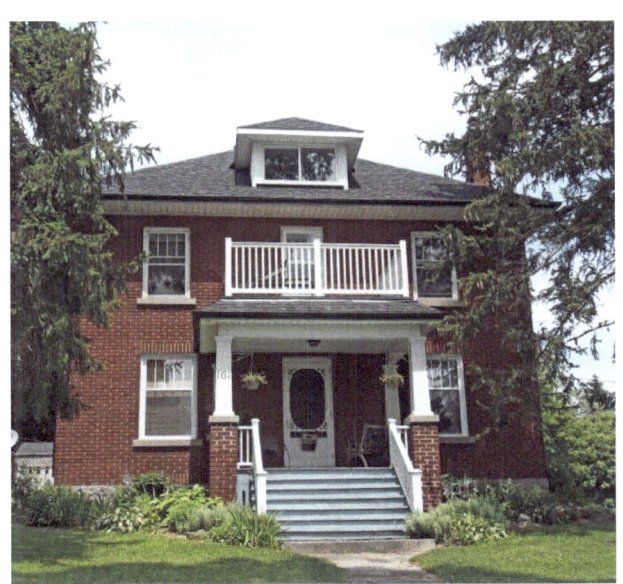

161 Widder Street East – hipped roof, dormer, second floor balcony

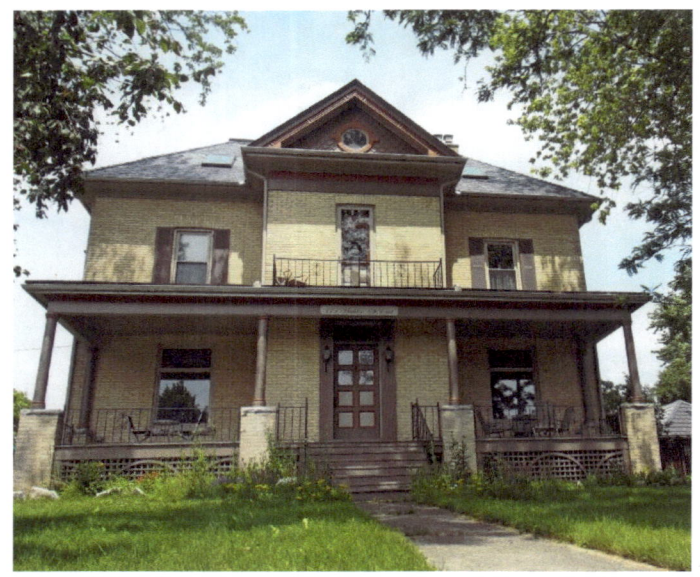

177 Widder Street East – second floor balcony

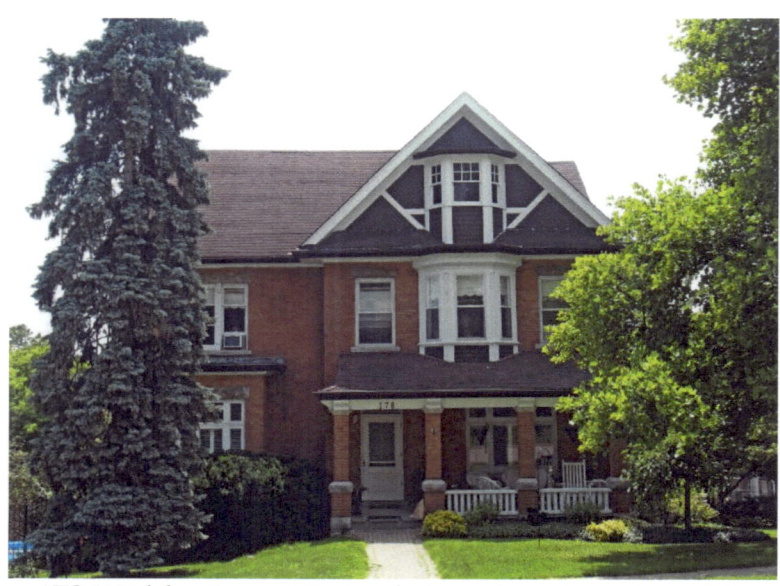

178 Widder Street East – fish scale pattern in gable

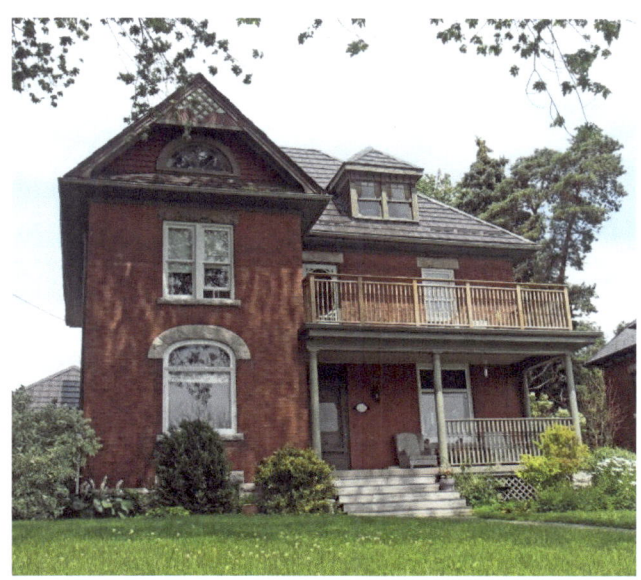

183 Widder Street East – Edwardian, dormer, second floor balcony, stone voussoir

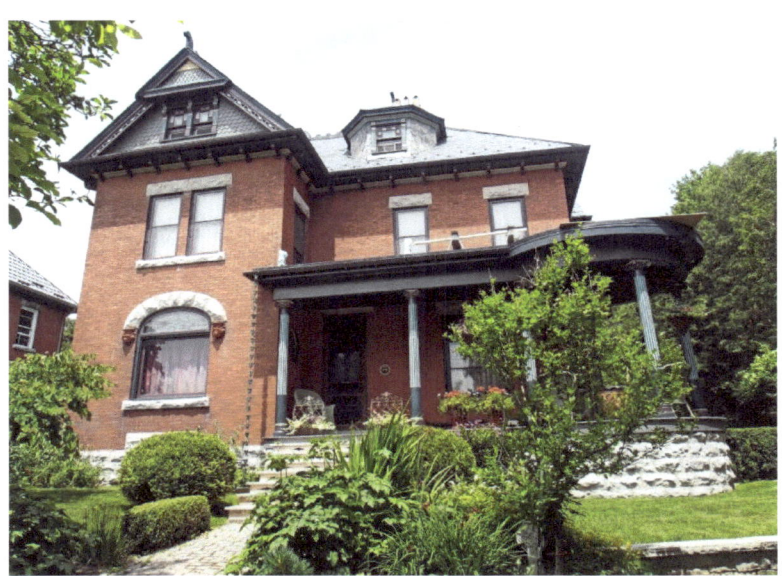

191 Widder Street East – 1900 – Edwardian – Ionic capitals on verandah pillars, stone voussoir with drip mould faces in terra cotta, stained glass window

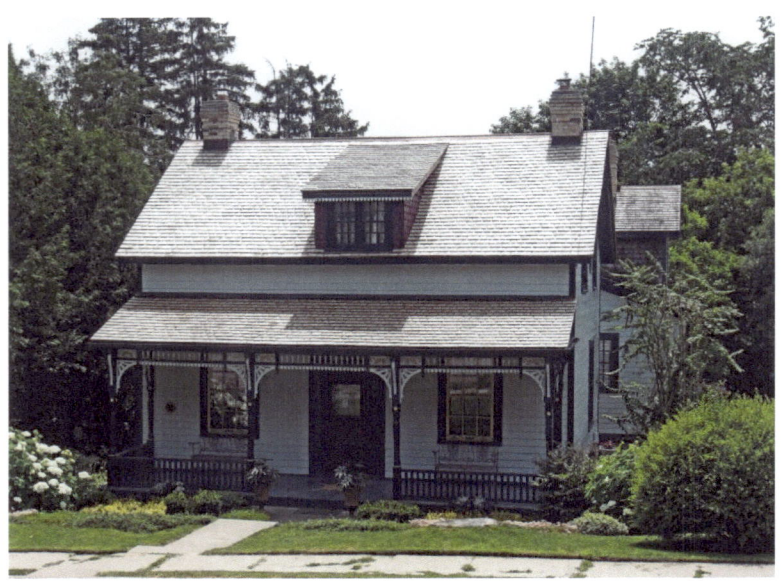

Widder Street East – 1873 – bric-a-brac with spindles and stencilling on verandah

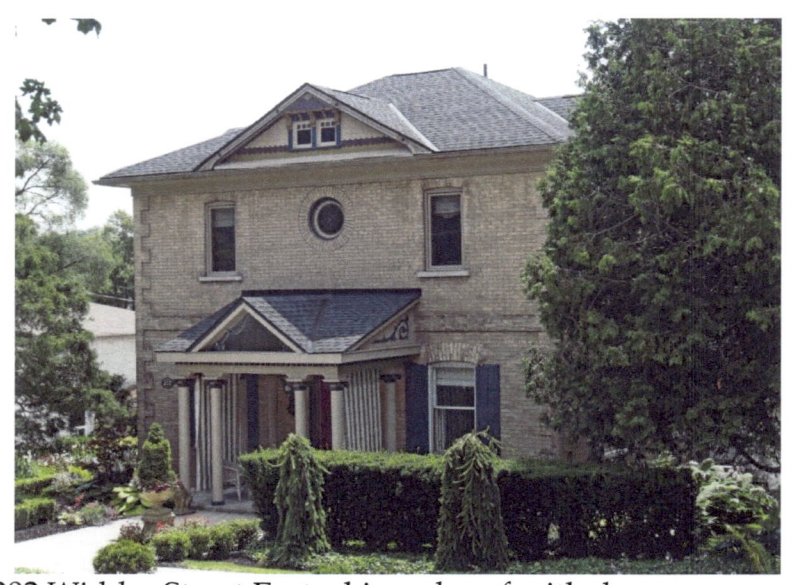

202 Widder Street East – hipped roof with dormer, corner quoins, pediment above porch

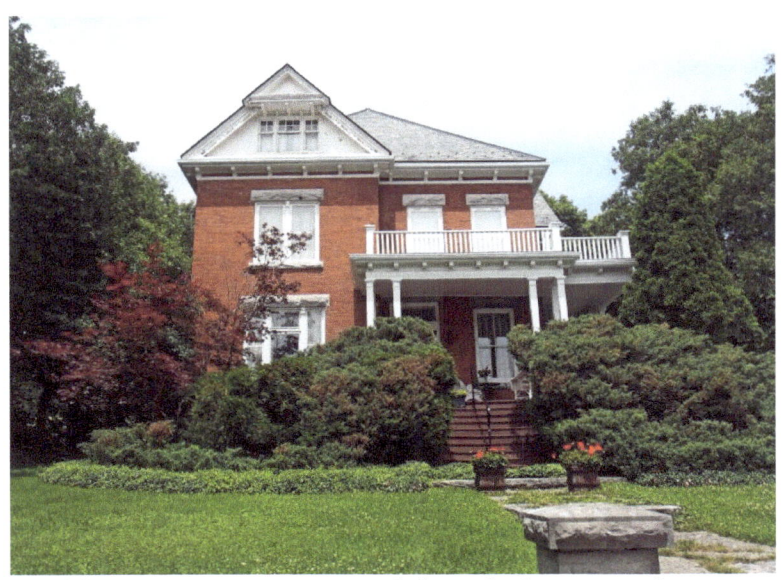

197 Widder Street East – second floor balcony on front, second floor verandah on side

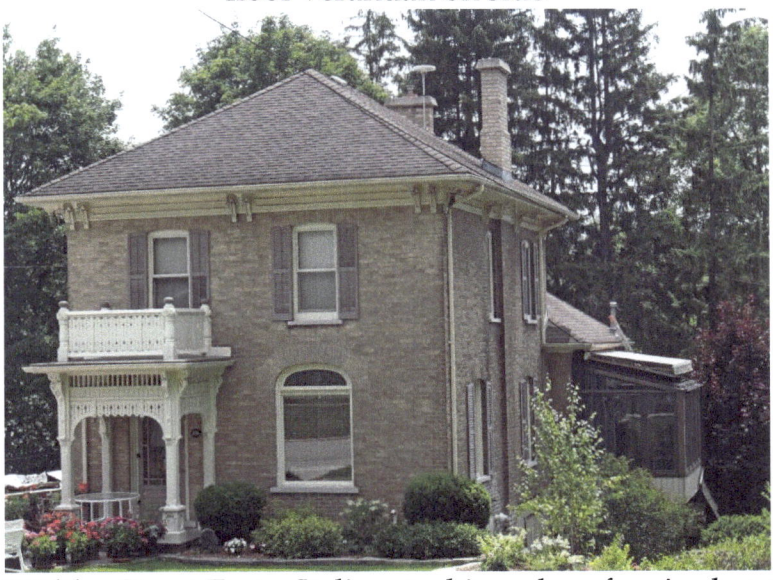

230 Widder Street East – Italianate, hipped roof, paired cornice brackets, second floor balcony above entrance with spindles and stenciling

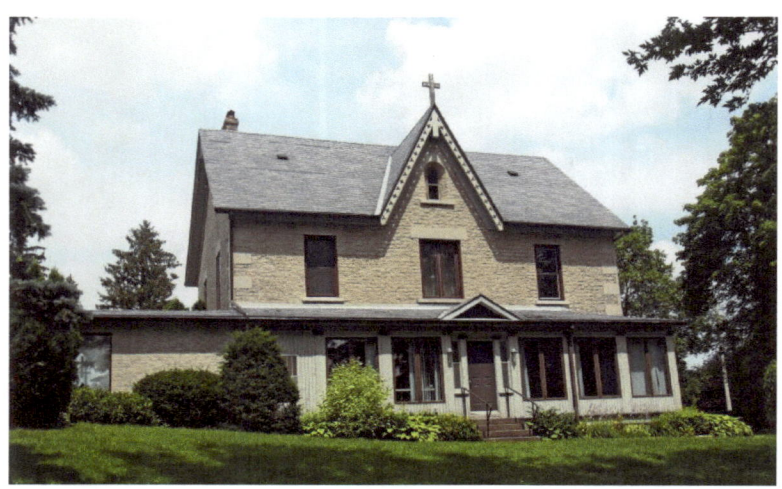

Widder Street East – Holy Name of Mary Catholic Church manse – Gothic Revival, verge board trim on gable, pediment

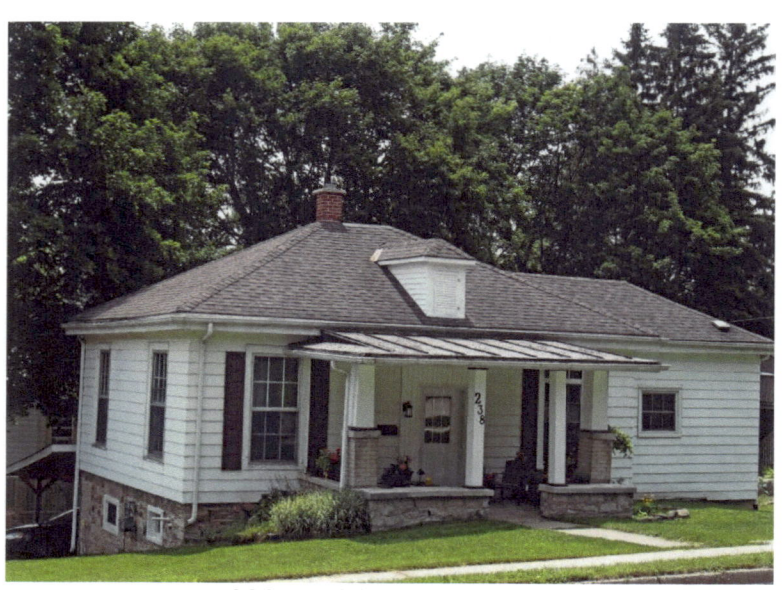

238 Widder Street East

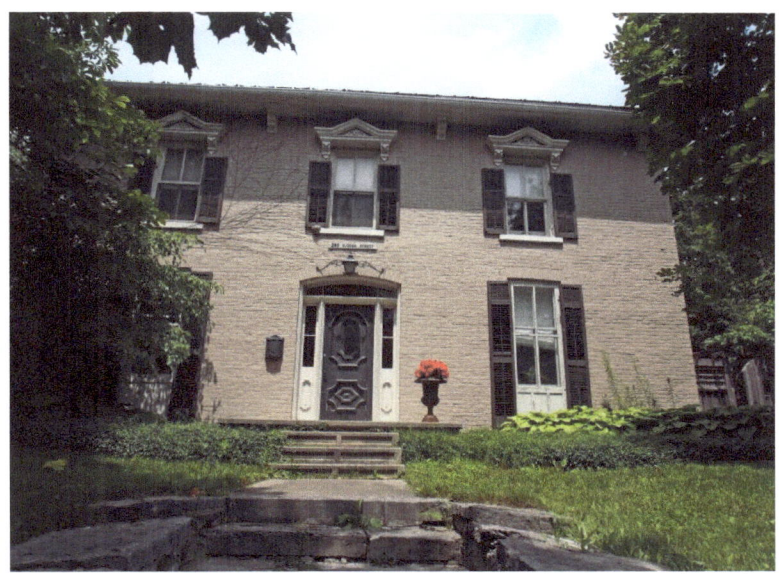

249 Widder Street East – Georgian, single cornice brackets, window hoods, sidelights and transom windows,

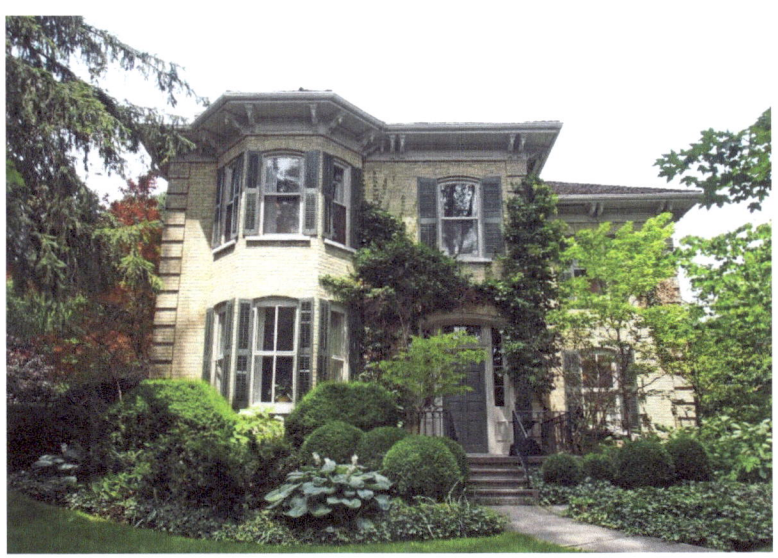

261 Widder Street East – Italianate, cornice brackets, two-storey bay window, sidelights and transom

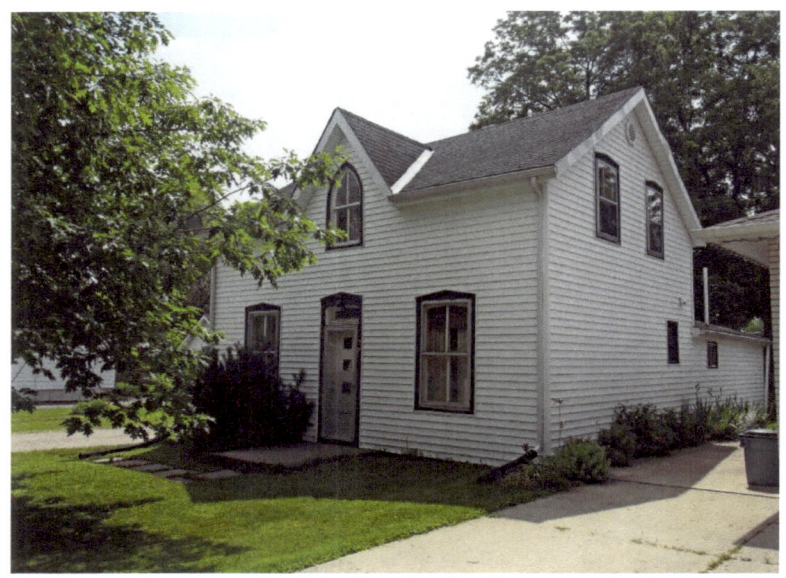

30 William Street – Gothic Revival – lancet window in front gable, transom window above door

William Street – one-storey Regency Cottage

Architectural Terms

Bay Window: A window that projects out from a wall, in a semicircular, rectangular, or polygonal design. Used frequently in Gothic and Victorian designs. Example: 109 Wellington Street North, Page 10	
Brackets: a decorative or weight-bearing structural element which forms a right angle with one side against a wall and the other under a projecting surface such as an eave or roof. Example: 92 Wellington Street North, Page 8	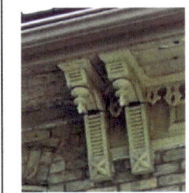
Buttress: a masonry structure built against or projecting from a wall which serves to support or reinforce the wall. In Canadian architecture, they are sometimes used for decoration. Example: 147 Widder Street East, Page 27	
Capital: The uppermost finish or decoration on a column. An Ionic column has a small base, a thin elegant shaft, and a capital composed of volutes which are carved whirls or twists that take the form of a scroll. Example: 191 Widder Street East, Page 31	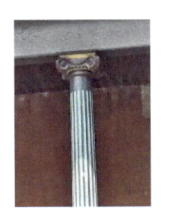
Cornice Return: decorative element on the end of a gable. Example: 223 Wellington Street South, Page 18	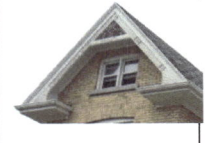

Dentil Moulding: an even series of rectangles used as ornamental decoration in cornices. Example: Widder Street, Page 29	
Dichromatic brickwork: the use of two colours of brick, tile or slate to decorate a façade. Example: 147 Widder Street East, Page 28	
Dormer: (French for "sleep") a gable end window that pierces through the plane of a sloping roof surface to create usable space in the top floor or attic of a building by adding headroom. Example: Widder Street East, Page 29	
Entrance: The entrance encompasses the doorway and the inner vestibule or, in residential architecture, the covered porch. Example: 92 Wellington Street North, Page 8	
Gable: the triangular portion of a wall between the edges of a sloping roof. **Jacobean Gable:** the gable extends above the roofline. Example: 92 Wellington Street North, Page 8	

Hipped Roof: a roof where all sides slope downwards to the walls with no gables. Example: 230 Widder Street East, Page 33	
Iron Cresting: A decorative ornament along the top of a roof. Iron cresting was popular in the Baroque era and also in Italianate, Victorian, Second Empire and Queen Anne styles of architecture. Example: 92 Wellington Street North, Page 8	
Keystones and Voussoirs: a voussoir is a wedge-shaped element used in building an arch. A keystone is the central stone that locks all the stones into position, allowing the arch to bear weight. A keystone is often enlarged and embellished. Example: 191 Widder Street East, Page 31	
Lancet Window: a tall, narrow window with a pointed arch at its top. Example: 147 Widder Street East, Page 27	
Palladian Window: a large window that is divided into three sections with the centre section larger than the two side sections and usually arched. Example: 89 Wellington Street North, Page 8	

Pediment: a triangular section above the horizontal structure (entablature), typically supported by columns. The inside of the triangle is called the tympanum. Example: 130 Wellington Street South, Page 13	
Quoin: masonry blocks at the corner of a wall, often a decorative feature, usually larger or of a different colour than the rest of the wall. Example: 109 Wellington Street North, Page 10	
Rose Window: a circular window with ornamental tracery radiating from the centre. Example: 147 Widder Street East, Page 27	
Sidelight: a window, usually with a vertical emphasis, that flanks a door, and is often used to emphasize the importance of a primary entrance. **Transom Window:** the light above the doorway, also called a fanlight. Example: 249 Widder Street East, Page 35	

Turret: a small tower that projects from the wall of a building. Example: 59 Wellington Street South, Page 26	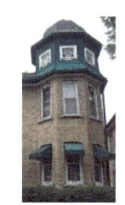
Vergeboard and Finial: also called bargeboards – hang from the projecting end of a roof and are often elaborately carved and ornamented. **Finial:** ornament added to the top of a gable, pinnacle, canopy or spire – a Gothic element. Example: 146 Wellington Street North, Page 11	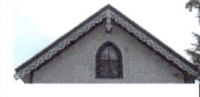
Window Hood: A **hood** is the piece found above window openings, usually of an ornate design, and covers the top third of the opening. Hoods are commonly placed above arched or curved openings on both windows and doors. Example: 230 Widder Street East, Page 33	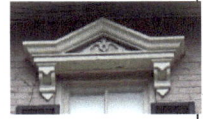

Building Styles

Edwardian, 1900-1930 – This style bridges the ornate and elaborate styles of the Victorian era and the simplified styles of the 20th century. Balanced facades, simple roof lines, dormer windows, large front porches, and smooth brick surfaces are its characteristics. Example: 187 Wellington Street South, Page 20	
Georgian, before 1860 – This style began with the British King Georges in the 18th century. These buildings have balanced facades around a central door, medium-pitched gable roofs, and small paned windows. Example: 249 Widder Street East, Page 35	
Gothic Revival, 1830-1890 – These decorative buildings have sharply-pitched gables with highly detailed verge boards, pointed-arch window openings, and dichromatic brickwork. It is a common style in Ontario. Example: 146 Wellington Street North, Page 11	
Italianate, 1850-1900 – It has wide-bracketed eaves, belvederes, wrap-around verandahs. Example: 261 Widder Street East, Page 35	

Queen Anne, 1885-1900 – This style is distinguished by an irregular outline featuring a combination of an offset tower, broad gables, projecting two-storey bays, verandahs, multi-sloped roofs, and tall, decorative chimneys. A mixture of brick and wood is common. Windows often have one large single-paned bottom sash and small panes in the upper sash. Example: 59 Wellington Street South, Page 26	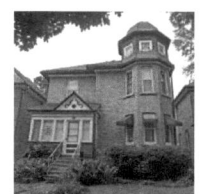
Regency Cottage, 1830-1860 – This style originated in England in 1815 and spread to Ontario later in the 19th century as British officers retired to Canada. It is a modest one-storey house with a low-pitched hip roof and has a symmetrical front façade. Example: 106 Wellington Street North, Page 9	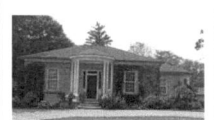
Vernacular/Traditional Mode 1638 - 1950 Influenced but not defined by a particular style, vernacular buildings are made from easily available materials and exhibit local design characteristics. Example: 223 Wellington Street South, Page 18	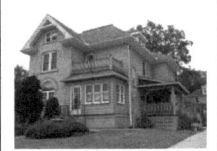

www.ingramcontent.com/pod-product-compliance
Lightning Source LLC
Chambersburg PA
CBHW040929180526
45159CB00002BA/672